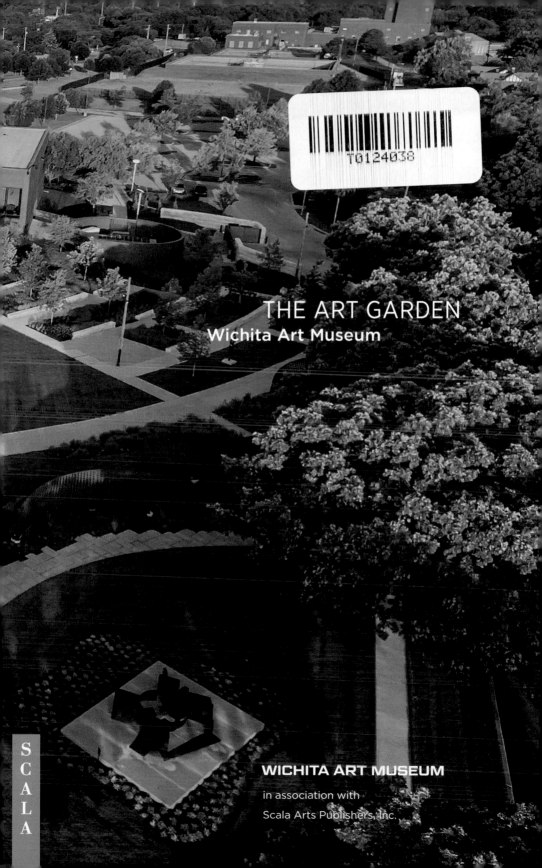

THE ART GARDEN
Wichita Art Museum

T0124038

SCALA

WICHITA ART MUSEUM

in association with
Scala Arts Publishers, Inc.

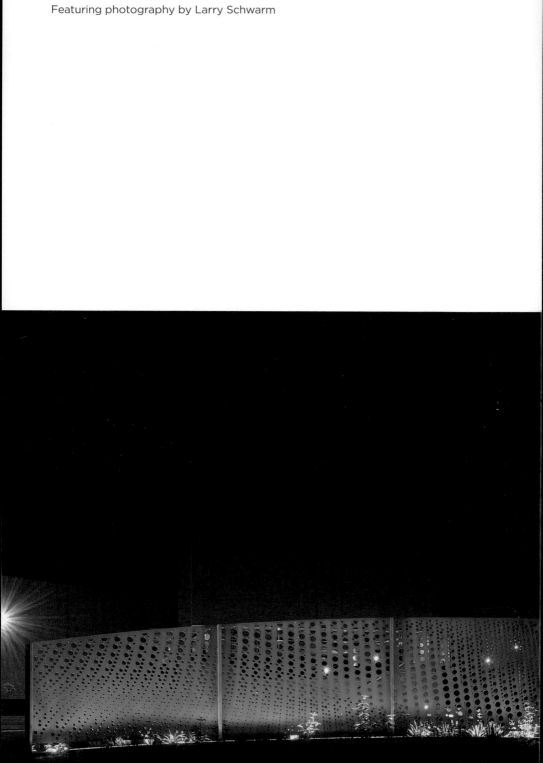

Featuring photography by Larry Schwarm

# Contents

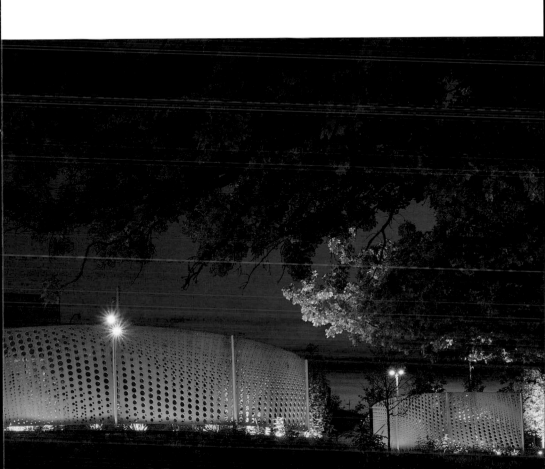

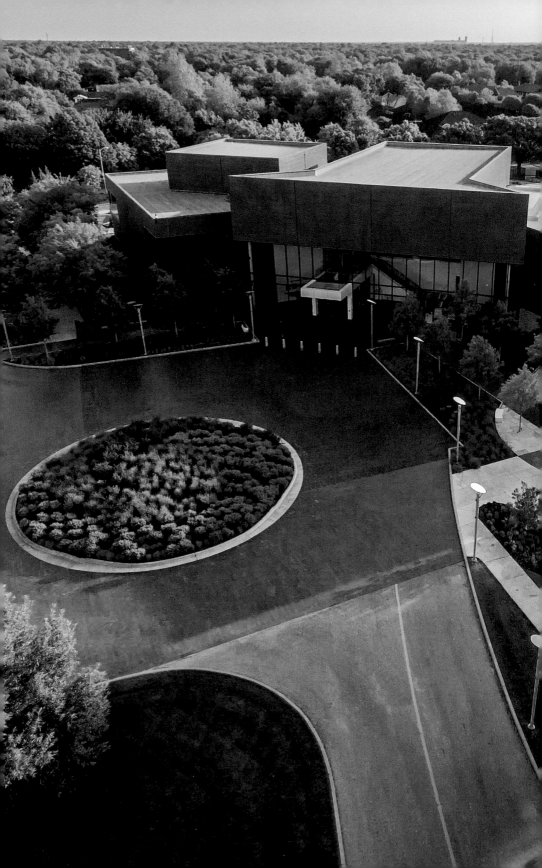

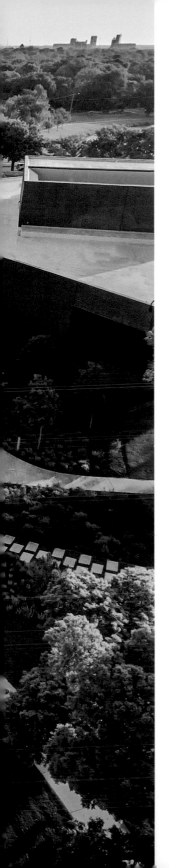

Wichita is the largest city in Kansas, and the metropolitan area represents a population of roughly 700,000. Wichitans are proud Midwesterners with a strong sense of place and community-mindedness. This ethic situated in the heartland and within the vast American prairie fosters a city that prospers economically as well as in the arts. The Air Capital of the World, a moniker adopted in the 1920s to reflect the city's might in aviation design and manufacturing, Wichita is now a national leader in aviation as well as agriculture, oil, engineering, entrepreneurship, and burgeoning media and tech industries. The Wichita Art Museum, founded in 1935, is one of the leading cultural lights for the city and region.

## The Story of the Art Garden at Wichita Art Museum

The Wichita Art Museum focuses on American art. This emphasis started with the generosity of one of Wichita's first families and creators of a local publishing dynasty, the Murdocks. In 1915, Louise Caldwell Murdock bequeathed substantial funds to acquire a distinguished American art collection. One hundred sixty-nine works comprise the Roland P. Murdock Collection, named for Louise's husband who was publisher and editor of the *Wichita Eagle* at the turn of the century. To house and care for that collection, the City of Wichita built the first museum facility on park land. Expanded several times since opening in 1935, the museum thrives north of downtown along the Arkansas River, its comprehensive collection now 9,000 works strong.

In 2015, the Wichita Art Museum opened the Art Garden, a reinvention of the eight acres surrounding the museum building. The grounds were transformed from standard to stunning. The landscape design and urban planning firm Confluence—a Midwestern leader with offices in Des Moines, Kansas City, and Minneapolis—created the garden's dynamic plan. Many tons of earth shaped new slopes and outdoor rooms. More than one hundred trees and 20,000 plants added natural beauty. Consistent with the city's pride of

place, the landscape reflects the archetypes of the prairie environment and today's priority for ecological sustainability. With a new amphitheater, expansive sculpture plaza, river views, and lush landscaping redolent of Kansas scenes, the Wichita Art Museum Art Garden melds art and nature, urban leisure and aesthetic enrichment.

Featured in this landscape are eleven outdoor artworks, among them stunning examples by renowned sculptors Henry Moore, Tom Otterness, and Jun Kaneko. With support from the Friends of the Wichita Art Museum, two site-specific artworks were commissioned specifically for the Art Garden. *Pulse Field* by artist Derek Porter offers a light sculpture that enhances the museum entry with lyrical poetry each evening into the night. *Wind Screens* by Vicki Scuri define the northern garden periphery as looming Cor-Ten arcs gently hug the curvature of berms enlivened by native grasses and flowering perennials.

A deep commitment to community infuses the purpose of the Wichita Art Museum. Aligning with its mission to serve, the Art Garden enhances the museum grounds and offers compelling art experiences to those who call Wichita and the State of Kansas home. The Art Garden is a virtual welcome mat to the community, extending the oasis of beauty found inside its galleries to the landscape outside.

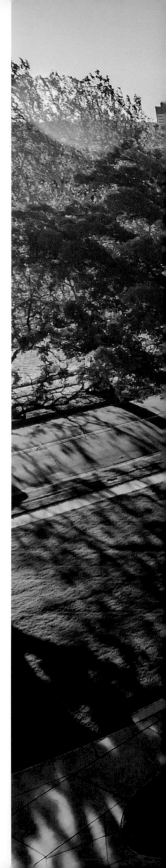

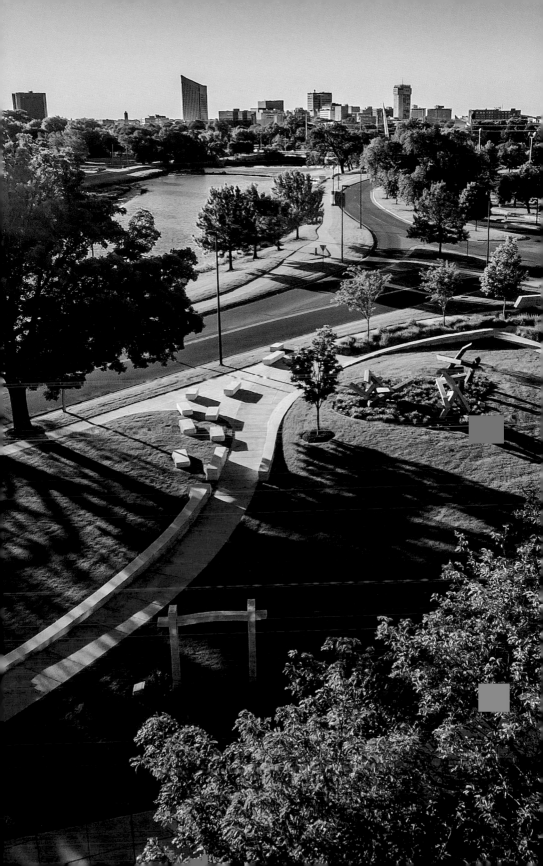

If you want to build a ship, don't herd people together to collect wood and don't assign them tasks and work, but rather teach them to long for the endless immensity of the sea.

—Antoine de Saint-Exupéry

Barry and Paula Downing

Keith and Martie Walker

The Art Garden is the dream of two inspiring visionaries, Wichita Art Museum board members Paula Downing and Martie Walker. Typically, a project of the garden's scale and ambition would develop from institutional long-term planning. Paula and Martie had the rare ability to see a clear need, propose the idea to museum leadership, and provide major lead gifts. Together, these visionary women conceived and launched the project for a world-class landscape environment. They inspired the museum to look ahead and outward.

## Art Garden Visionaries

Rebecca Hoyer

**The Girl in the White Dress**, 2015
Oil on masonite
14 x 11 inches
Gift of the artist

**Outer Sanctum**, 2015
Oil on masonite
16 x 20 inches
Gift of the artist

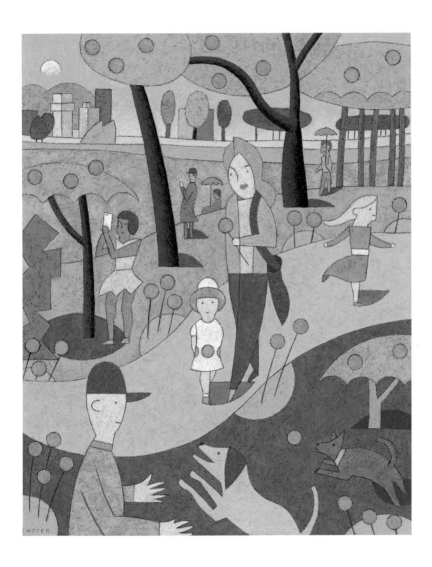

French impressionist Georges Seurat's famous nineteenth-century painting **A Sunday on La Grande Jatte** celebrated Parisians enjoying urban leisure by the river Seine. With the Art Garden, city dwellers of Wichita similarly enjoy the beautiful outdoors by the river. In homage to Seurat and to celebrate its new garden, the museum commissioned Wichita painter Rebecca Hoyer to create an artistic quotation of **La Grande Jatte**. Her two paintings feature the unique setting of Wichita's skyline, river, and museum, and they lend a jaunty twenty-first-century twist to enjoying city life outdoors. Following their use in promoting the Art Garden, the artist generously donated the artworks to the museum.

# Art Garden Imagined

Outdoor Sculpture

**Douglas Abdell**

**Kaephae-Aekyad #2**, 1979
Welded steel
96 x 112 x 22 inches
Museum Purchase with funds
donated by The Price R. and
Flora A. Reid Foundation and
Friends of the Wichita Art Museum

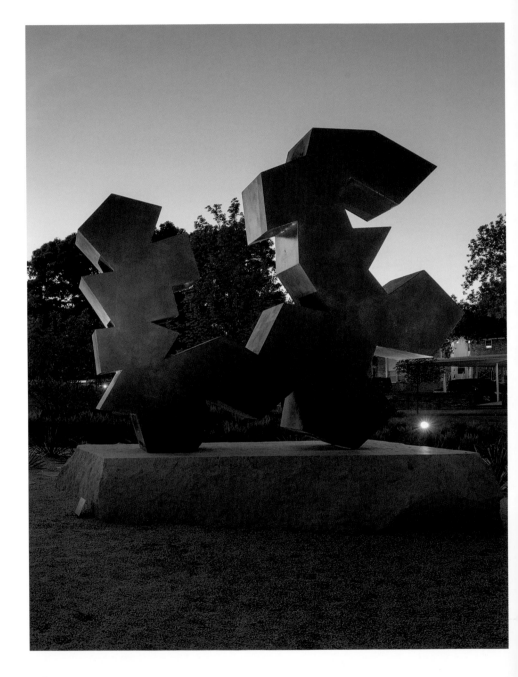

**Stanley Boxer**

**Three Part Marble White**, 1971
Carrara marble
105 x 119 ½ x 16 inches
Gift of Mr. and Mrs. Samuel Dorsky

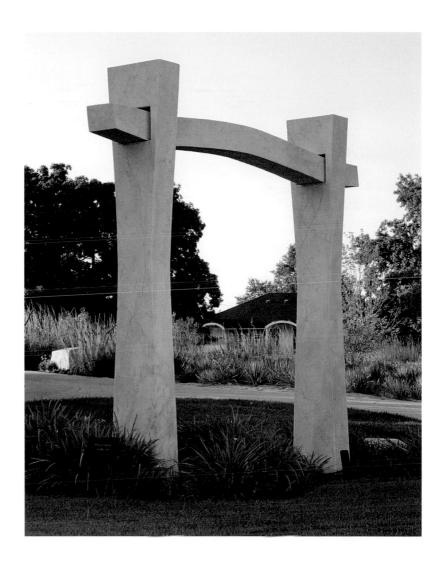

**Tony Hochstetler**

**Sophie**, 1990
Cast bronze
57 x 37 ½ x 35 inches
Museum Purchase, Burneta Adair
Endowment Fund

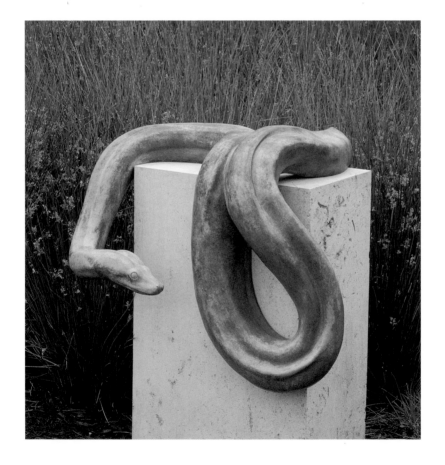

Steve Kestrel

**Spectre of Ancient Pathways**, 1989
Cast bronze on limestone base
50 x 64 x 23 inches
Museum Purchase, Burneta Adair
Endowment Fund

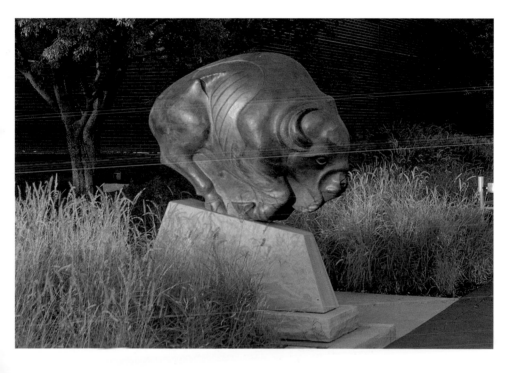

**Henry Moore**
**Working Model for Three Piece
No. 3: Vertebrae**, 1968
Cast bronze
42 x 93 x 48 inches
Museum Purchase with funds
donated by Friends and
Franchisees of Pizza Hut, Inc.
in honor of Dan and Frank Carney

**Tom Otterness**
**Dreamers Awake**, 1995
Cast bronze
15 x 30 x 20 feet
Museum Purchase, Burneta Adair
Endowment Fund

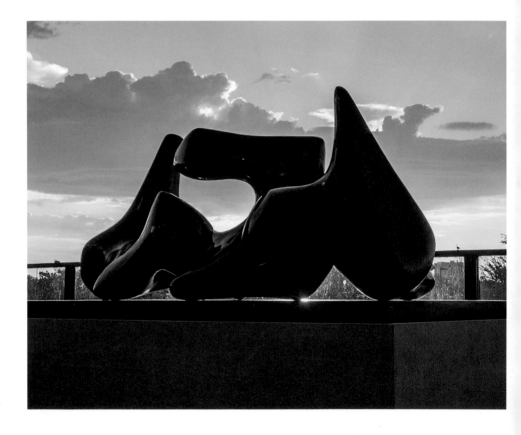

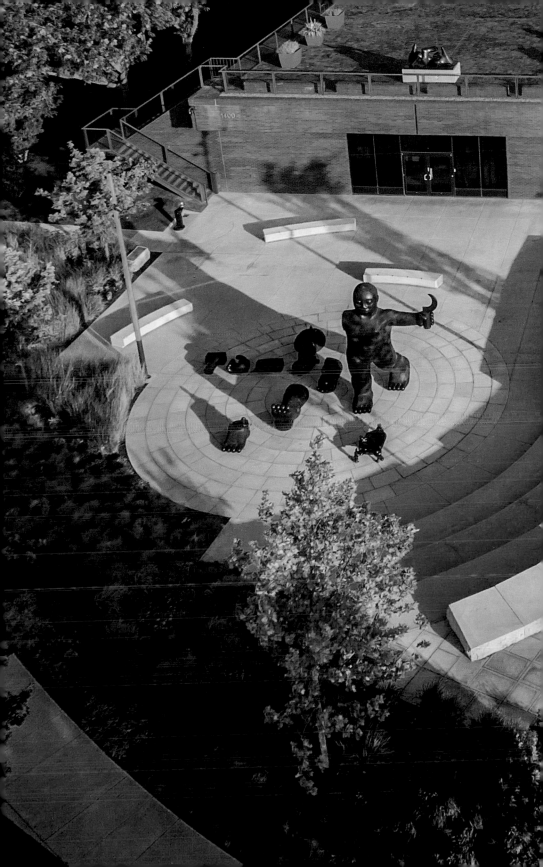

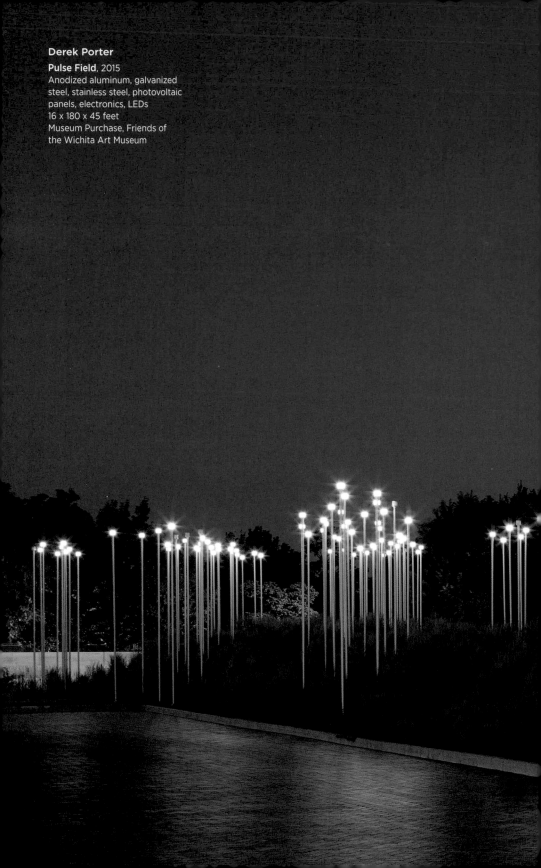

**Derek Porter**
**Pulse Field**, 2015
Anodized aluminum, galvanized
steel, stainless steel, photovoltaic
panels, electronics, LEDs
16 x 180 x 45 feet
Museum Purchase, Friends of
the Wichita Art Museum

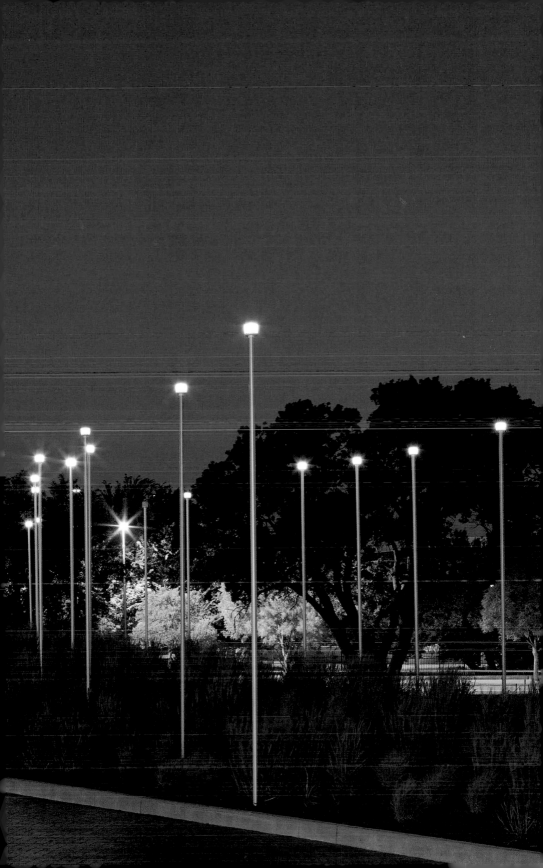

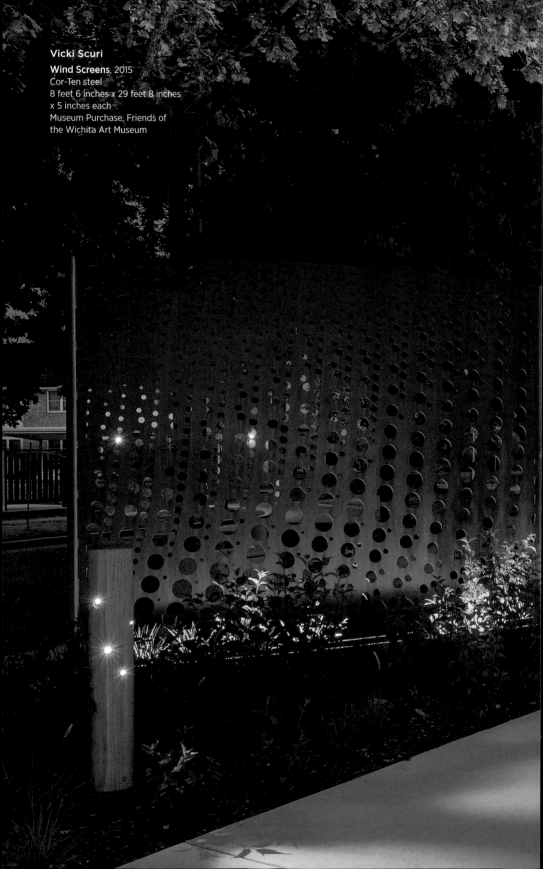

**Vicki Scuri**
**Wind Screens**, 2015
Cor-Ten steel
8 feet 6 inches x 29 feet 8 inches
x 5 inches each
Museum Purchase, Friends of
the Wichita Art Museum

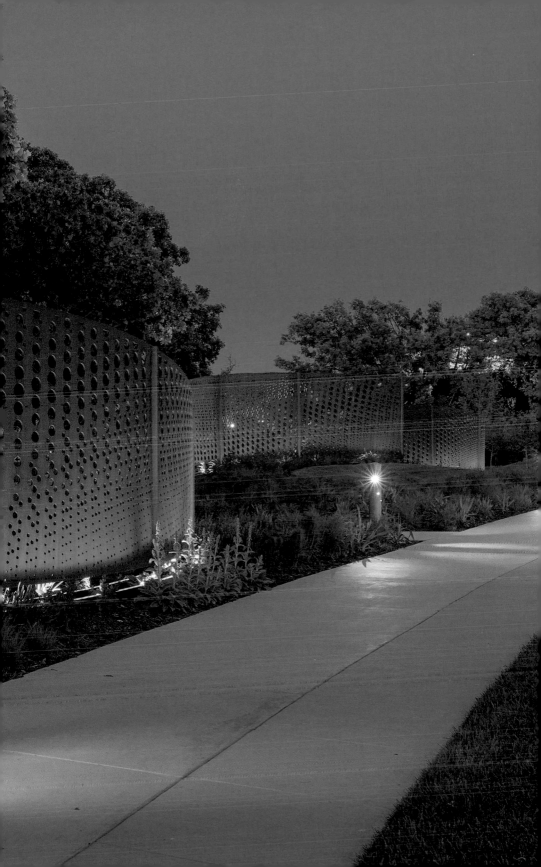

**Ernest C. Shaw**

**Cluster IV**, 1979
Welded and painted Cor-Ten steel
8 x 30 x 30 feet
Gift of Mr. and Mrs. Joseph Albenda

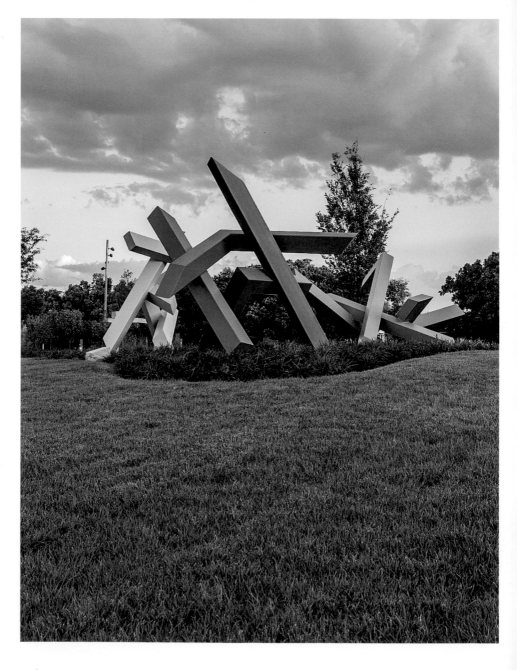

**Isaac Witkin**

**Yantra**, 1977
Steel
5 x 19 ½ x 12 feet
Gift of Francoise and
Harvey Rambach

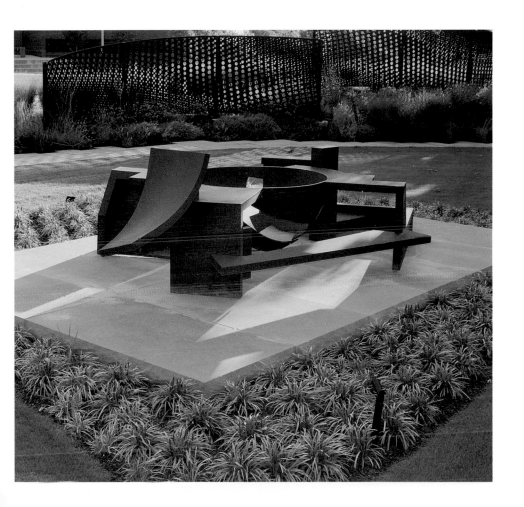

## OVERSTORY TREES

**BALD CYPRESS**
*Taxodium distichum* var. *distichum*

**EXCLAMATION LONDON PLANETREE**
*Platanus x acerifolia* "Morton Circle"

**GREEN VASE JAPANESE ZELKOVA**
*Zelkova serrata* "Green Vase"

**LACEBARK ELM**
*Ulmus parvifolia*

**SHUMARD OAK**
*Quercus shumardii*

**SUGAR MAPLE**
*Acer saccharum*

**SWAMP WHITE OAK**
*Quercus bicolor*

## UNDERSTORY TREES

**ARISTOCRAT PEAR**
*Pyrus calleryana* "Aristocrat"

**AUTUMN BRILLIANCE SERVICEBERRY**
*Amelanchier x grandiflora* "Autumn Brilliance"

**CHINESE FRINGETREE**
*Chionanthus retusus*

**EASTERN REDBUD**
*Cercis canadensis*

**FLAME AMUR MAPLE**
*Acer tataricum* subsp. *ginnala* "Flame"

**SPRING SNOW FLOWERING CRABAPPLE**
*Malus* "Spring Snow"

## DECIDUOUS SHRUBS

**ALICE OAKLEAF HYDRANGEA**
*Hydrangea quercifolia* "Alice"

**BUTTERFLY BUSH HYBRID**
*Buddleia* Flutterby Petite™ Tutti Fruitti Pink

**BUTTONBUSH**
*Cephalanthus occidentalis*

**DWARF KOREAN LILAC**
*Syringa meyeri* "Palibin"

**RUBY SPICE SUMMERSWEET**
*Clethra alnifolia* "Ruby Spice"

**SMOOTH SUMAC**
*Rhus glabra*

## EVERGREEN SHRUBS

**ADAM'S NEEDLE**
*Yucca filamentosa*

**COLOR GUARD YUCCA**
*Yucca filamentosa* "Color Guard"

**GOLDEN SWORD YUCCA**
*Yucca filamentosa* "Golden Sword"

**HETZI COLUMNAR JUNIPER**
*Juniperus chinensis* "Hetzii Columnaris"

# Plant List

## PERENNIALS

**AMERICAN BELLFLOWER**
*Campanula americana*

**AUTUMN JOY SEDUM**
*Sedum "Autumn Joy"*

**BLACK-EYED SUSAN**
*Rudbeckia hirta*

**BLUE FALSE INDIGO**
*Baptisia australis*

**BLUE VERVAIN**
*Verbena hastata*

**BUTTERFLY WEED**
*Asclepias tuberosa*

**CAESAR'S BROTHER SIBERIAN IRIS**
*Iris sibirica "Caesar's Brother"*

**COCONUT LIME CONEFLOWER**
*Echinacea purpurea "Coconut Lime"*

**COMPASS PLANT**
*Silphium laciniatum*

**DARK EYES FOAMFLOWER**
*Tiarella cordifolia "Dark Eyes"*

**DARK TOWERS BEARDTONGUE**
*Penstemon "Dark Towers"*

**FALSE SUNFLOWER**
*Heliopsis helianthoides*

**HELEN VON STEIN LAMB'S EAR**
*Stachys byzantina "Helen Von Stein"*

**JOE PYE WEED**
*Eupatorium pupureum*

**KOBOLD GAYFEATHER**
*Liatris spicata*

**LILYTURF**
*Liriope muscari*

**MAGNUS PURPLE CONEFLOWER**
*Echinacea purpurea "Magnus"*

**MAY NIGHT SALVIA**
*Salvia x sylvestris "May Night"*

**PAPRIKA YARROW**
*Achillea millefolium "Paprika"*

**PRAIRIE BLAZINGSTAR**
*Liatris pycnostachya*

**PURPLE CONEFLOWER**
*Echinacea purpurea*

**RATTLESNAKE MASTER**
*Eryngium yuccifolium*

**ROCKETMAN RUSSIAN SAGE**
*Perovskia atriplicifolia "Rocketman"*

**ROUGH BLAZINGSTAR**
*Liatris aspera*

**ROYAL CANDLES DWARF SPIKE SPEEDWELL**
*Veronica spicata "Glory" Royal Candles*

**RUBY STAR PURPLE CONEFLOWER**
*Echinacea purpurea "Ruby Star"*

**SUMMER BEAUTY ALLIUM**
*Allium tanguticum "Summer Beauty"*

**SUNSET HYSSOP**
*Agastache rupestris*

**SWAMP MILKWEED**
*Asclepias incarnata*

**TERRA COTTA YARROW**
*Achillea millefolium "Terracotta"*

**WALKER'S LOW CATMINT**
*Nepeta x faassenii "Walker's Low"*

**WHITE FALSE INDIGO**
*Baptisia alba*

**WILD BERGAMOT**
*Monarda fistulosa*

## ORNAMENTAL GRASSES

**AUTUMN MOOR GRASS**
*Sesleria autumnalis*

**BOTTLEBRUSH GRASS**
*Elymus hystrix*

**CHEYENNE SKY SWITCHGRASS**
*Panicum virgatum "Cheyenne Sky"*

**DEWEY BLUE BITTER SWITCHGRASS**
*Panicum amarum "Dewey Blue"*

**INDIAN GRASS**
*Sorghastrum nutans*

**KARLEY ROSE FOUNTAIN GRASS**
*Pennisetum orientale "Karley Rose"*

**LITTLE BLUESTEM**
*Schizachyrium scoparium*

**NORTHERN SEA OATS**
*Chasmanthium latifolium*

**NORTHWIND SWITCHGRASS**
*Panicum virgatum "Northwind"*

**PRAIRIE DROPSEED**
*Sporobolus heterolepis*

**PRAIRIE JUNE GRASS**
*Koeleria macrantha*

**SHENANDOAH RED SWITCHGRASS**
*Panicum virgatum "Shenandoah"*

**SIDE OATS GRAMA**
*Bouteloua curtipendula*

**SOFT RUSH**
*Juncus effuses*

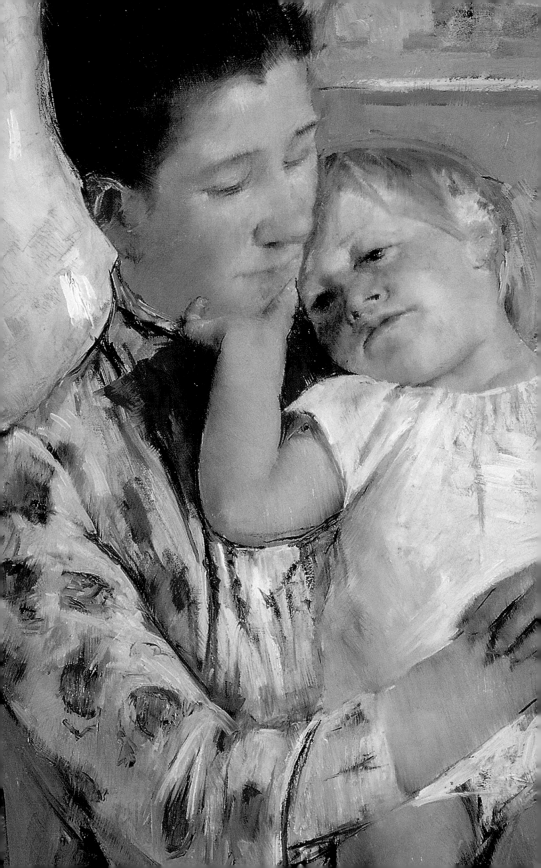

Highlights of the
Museum Collection

**John Singleton Copley**

**Mr. James Otis**, about 1760
Oil on canvas
50 ⅜ x 40 ¼ inches
Roland P. Murdock Collection

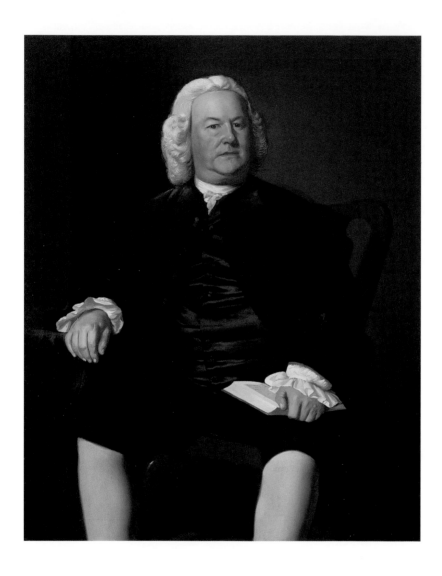

John Singleton Copley

**Mrs. James Otis**
**(Mary Allyne Otis)**, about 1760
Oil on canvas
50 ½ x 40 ⅝ inches
Roland P. Murdock Collection

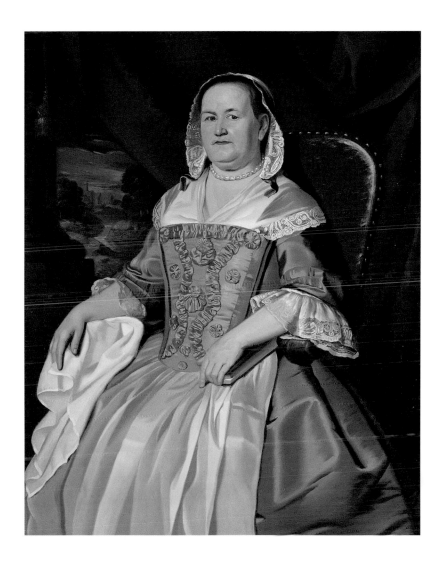

**Mary Cassatt**

**Mother and Child**, about 1890
Oil on canvas
35 ½ x 25 ⅜ inches
Roland P. Murdock Collection

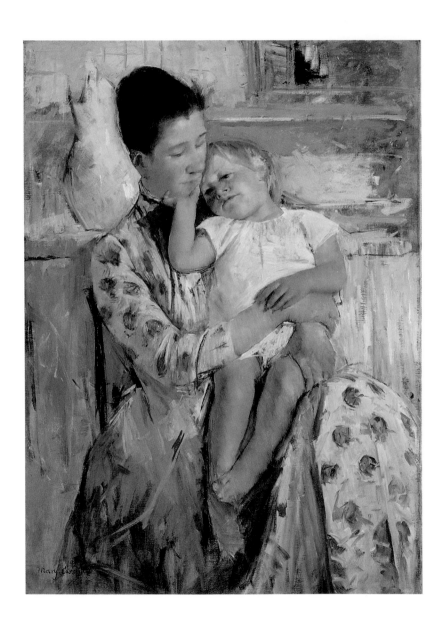

**Thomas Eakins**

**Mrs. Mary Hallock Greenewalt,**
1903
Oil on canvas
36 ⅛ x 24 ⅛ inches
Roland P. Murdock Collection

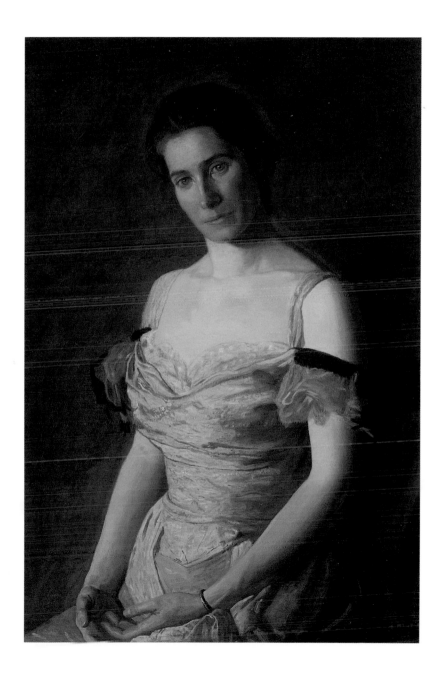

**Albert Pinkham Ryder**

**Moonlight on the Sea**, 1884
Oil on wood panel
11 ½ x 15 ⅞ inches
Roland P. Murdock Collection

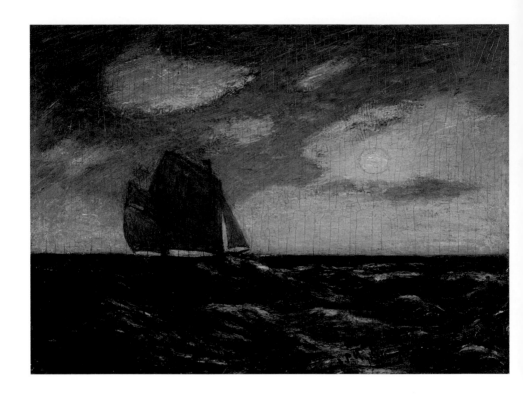

**John H. Twachtman**

**Falls in January**, about 1895
Oil on canvas
25 x 30 inches
Roland P. Murdock Collection

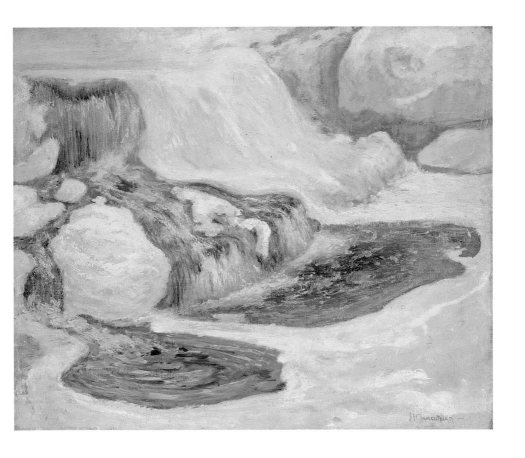

**Frederick Carder**
designer

**Steuben Division, Corning Glass Works**
manufacturer

**Vase** (Boothbay pattern), about 1925
Two-color acid-cut lead glass
13 ¾ x 9 ½ inches
Museum Purchase, F. Price Cossman
Memorial Trust, Intrust Bank, Trustee

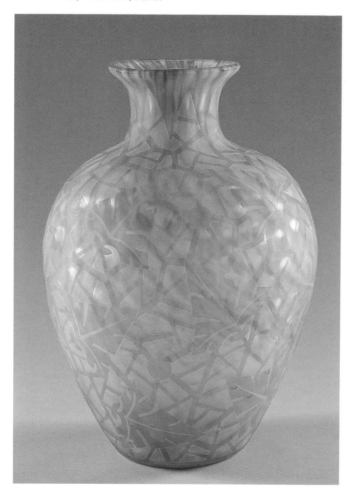

**Arthur G. Dove**

**Forms Against the Sun,**
about 1926
Oil on metal
29 x 21 inches
Roland P. Murdock Collection

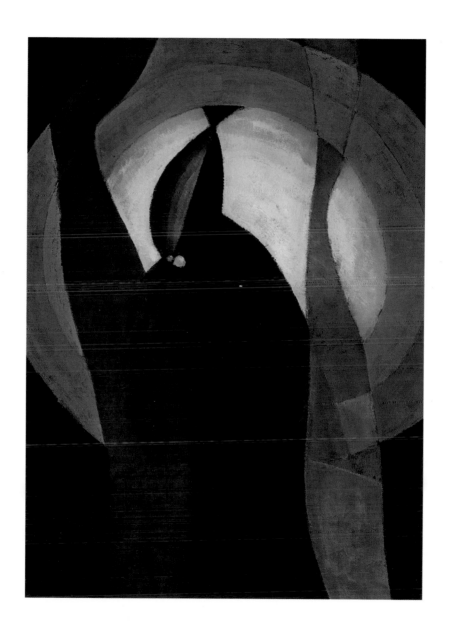

**Everett Shinn**

**The Monologist**, 1910
Pastel and gouache on paperboard
8 ¼ x 11 ¾ inches
Roland P. Murdock Collection

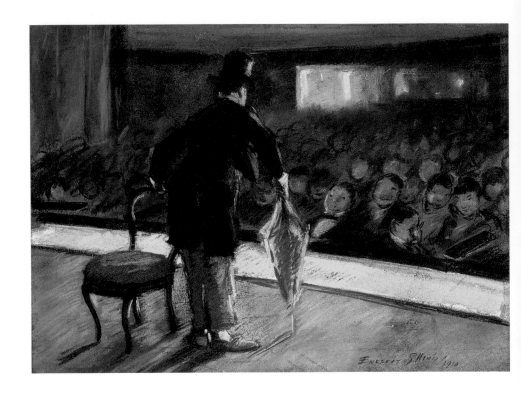

**Edward Hopper**

**Conference at Night**, 1949
Oil on canvas
28 ¼ x 40 ⁵⁄₁₆ inches
Roland P. Murdock Collection

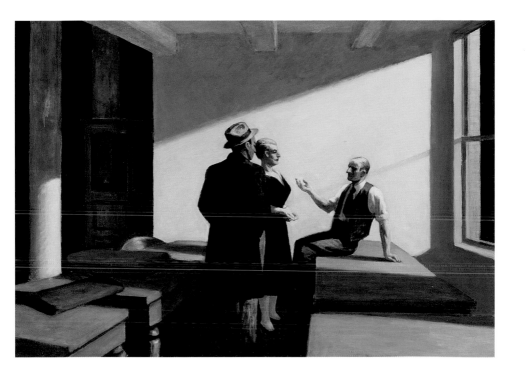

**Frances H. Gearhart**

**The Cloud**, about 1919–20
Color linocut on paper
9 ½ x 7 ½ inches
Museum Purchase, Prairie Print Makers
Purchase Fund

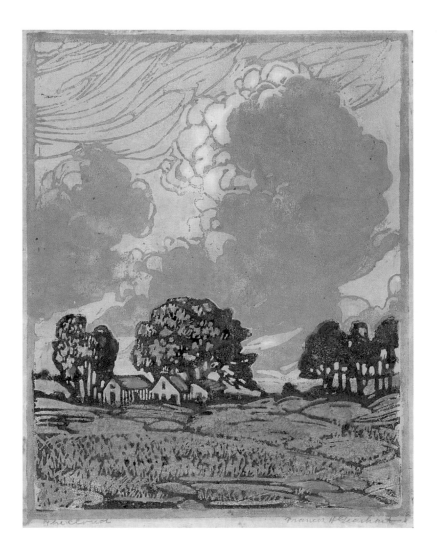

**Blackbear Bosin**

**Wichita, My Son**, 1965
Gouache on illustration board
40 ¾ x 62 inches
Gift of Mr. and Mrs. Henry A. Humphrey

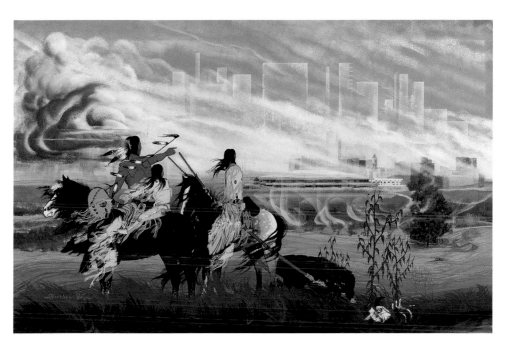

**John Steuart Curry**

**Kansas Cornfield**, 1933
Oil on canvas
60 ⅜ x 38 ⅜ inches
Roland P. Murdock Collection

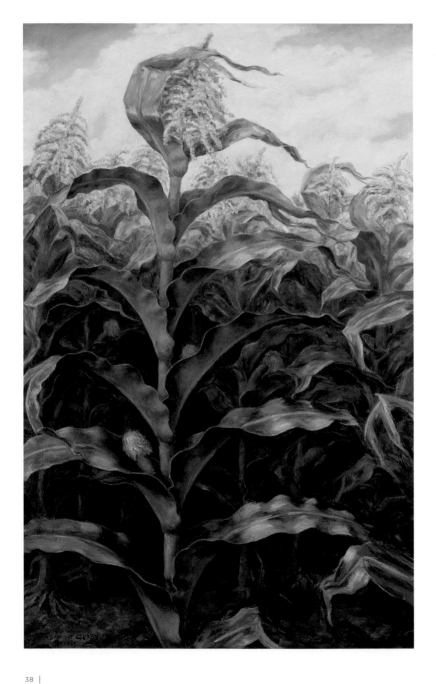

**Charles Burchfield**
**Winter Moonlight**, 1951
Watercolor on paper
40 x 33 inches
Roland P. Murdock Collection

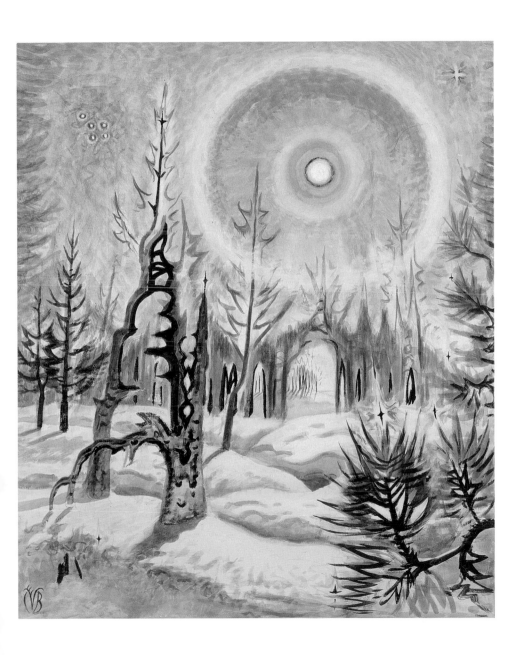

**Mark Tobey**

**Golden Gardens**, 1956
Tempera and graphite on paper
35 ¼ x 44 ¹³⁄₁₆ inches
Roland P. Murdock Collection

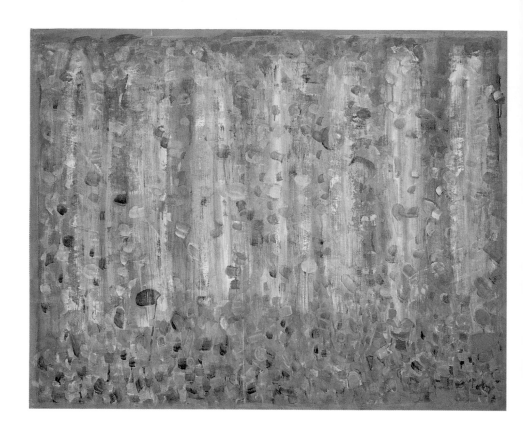

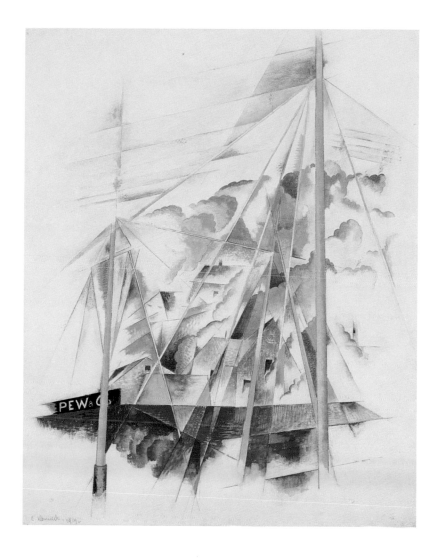

**Andrew Wyeth**

**The Captain's House**, about 1936
Watercolor on paper
17 x 29 inches
Bequest of Glenn L. and
Jayne Seydell Milburn

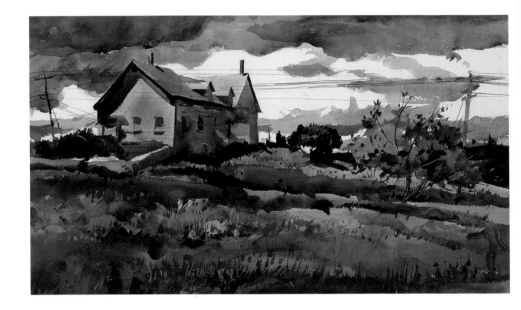

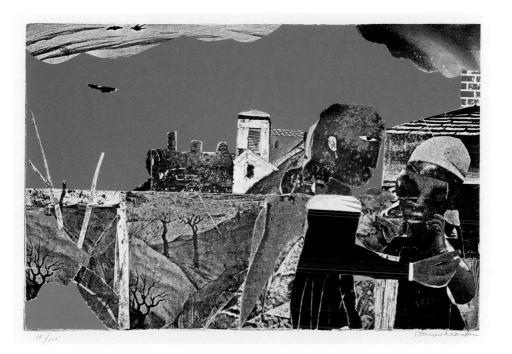

**Louise Nevelson**

**Night Sun III**, 1959–68
Wood
118 x 93 x 8 inches
Museum Purchase, Wichita Art
Museum Members Foundation

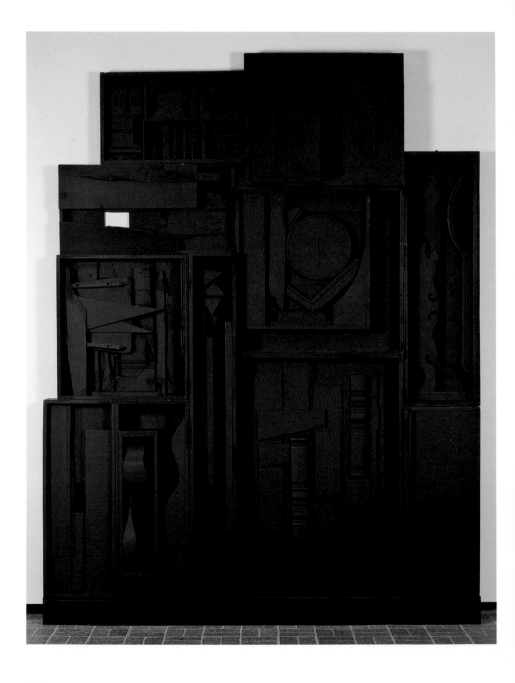

**Grace Hartigan**

**East River Drive**, 1957
Oil on canvas
70 ¼ x 79 ¼ inches
Museum Purchase, Robert and
Betty Foulston Fund

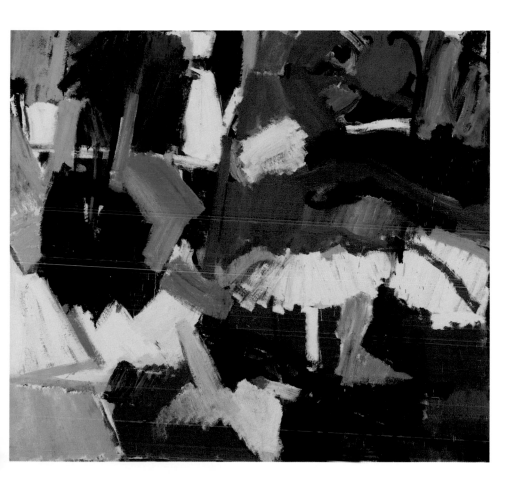

**Roger Shimomura**

**Untitled (Superman and Video),**
1985
Acrylic on canvas
60 x 72 ¼ inches
Museum Purchase, Burneta Adair
Endowment Fund

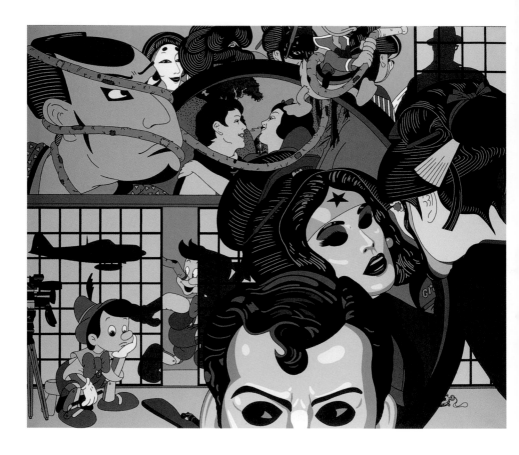

**David Salle**

**Butter Lane**, 1993
Oil and acrylic on canvas
84 x 60 inches
Museum Purchase, Burneta Adair
Endowment Fund

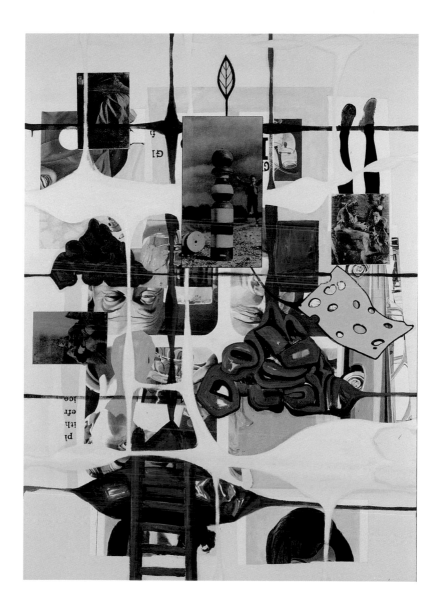

**Larry Schwarm**

**North of Lake Afton–Sedgwick
County, Kansas**, 2010
Inkjet
19 ¹⁵⁄₁₆ x 30 inches
Gift of an anonymous donor

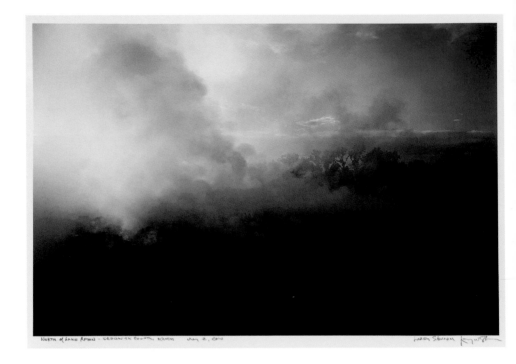

**Fred Wilson**

**Act V. Scene II—Exeunt Omnes,**
2014
Murano glass and wood
87 inches x 10 feet 9 inches x
8 ⅜ inches
Museum Purchase, F. Price Cossman
Memorial Trust, Intrust Bank, Trustee

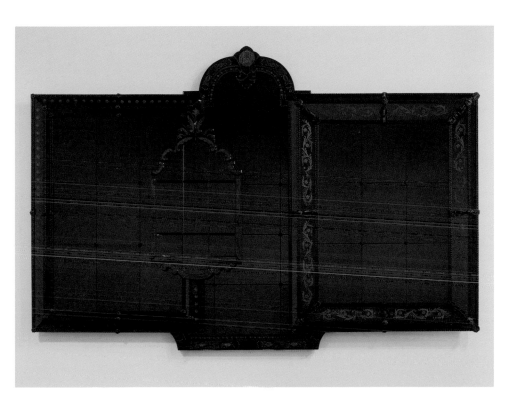

### DESIGN

**Confluence**

With Terry Berkbuegler, Brian Clark, Chris Cline, Matt Evett, and Jackie Kolpek

### OVERSIGHT CONSULTANT

**GLMV Architecture**

Jeff Van Sickle

Lori Guthridge

### COMMISSIONED ARTISTS

Derek Porter, New York

Vicki Scuri, Seattle

## CONSTRUCTION

**Simpson Construction, Inc.**

With Bob Simpson, Gregg Oblinger,
Chris Baalmann, Howard Thome

## CITY OF WICHITA CONSULTANTS

Larry Hoetmer and Rick Stubbs

## TECHNICAL CONSULTANTS

LightWorks, Inc.

Professional Engineering Consultants

## ART GARDEN COMMITTEE

Kevin Bishop, Myra Devlin, Paula Downing,
Larry Hoetmer, Jeff Kennedy, Patricia McDonnell,
Mike Michaelis, Pete Nelson, Elizabeth Stevenson,
Rick Stubbs, Lisa Volpe, Martha Walker

# Art Garden Cast and Creatives

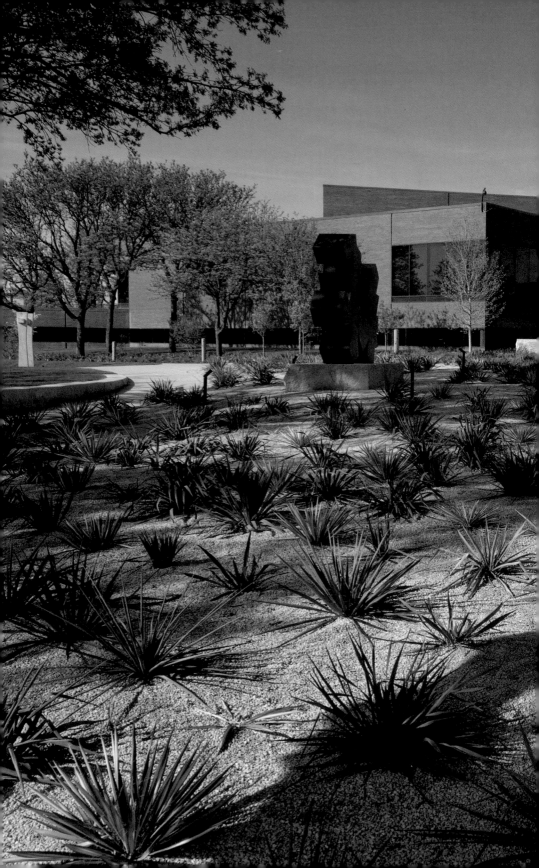

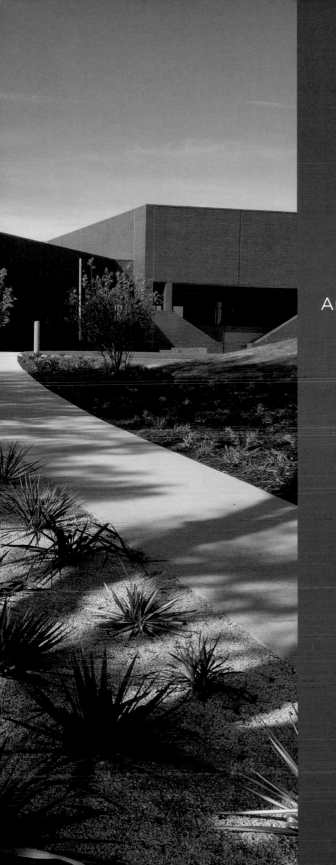

Art Garden Donors

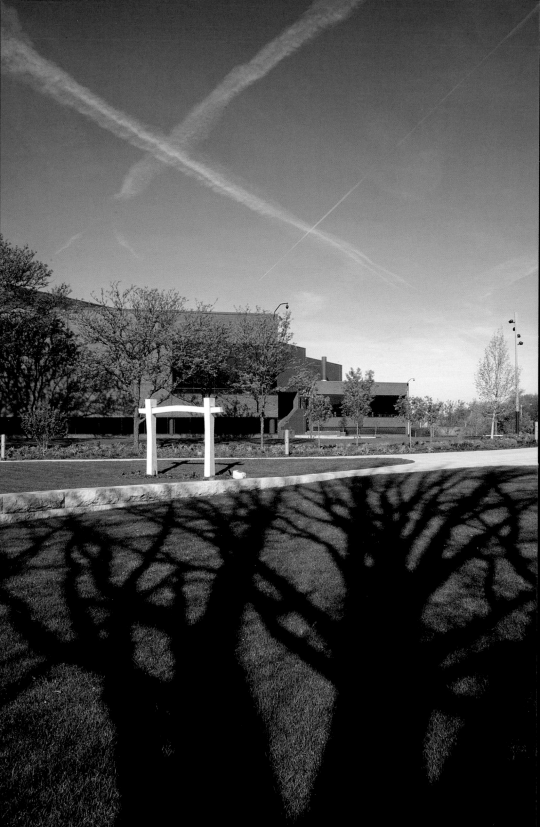

Initial support came from the Downing and Walker families. In 2015, a public campaign was launched with a transformational matching challenge by the Lattner Family Foundation. Because of their generous gift and the outpouring of support from Wichita Art Museum patrons, members, and the community, the museum met the challenge and opened the Art Garden on September 26, 2015.

## NAMED SPACES

Tom and Myra Devlin Desert Garden

Paula and Barry Downing Amphitheater

Lattner and Walker Family Plaza

Jayne Milburn Sculpture Plaza

Slawson Family North Garden

## ART GARDEN
## DIRECTOR'S CIRCLE

Paula and Barry Downing

Martha and Keith Walker

Lattner Family Foundation

Friends of the Wichita Art Museum

Mrs. Jayne Milburn*

Mrs. Judy Slawson

Tom and Myra Devlin

Nancy and Tom Martin

Emprise Bank

Mike and Dee Michaelis

Sondra M. Langel

Richard D. Smith

Jeff Kennedy and Patricia Gorham

Jan and Steve Randle

* *deceased*

## ART GARDEN BENEFACTORS
## AND PATRONS

Mary Eves and Rigby Carey

Ann and Martin Bauer

Helen and Ed Healy

Mrs. Sarah Smith

Toni and Bud Gates

Bill and Mary Lynn Oliver

Scott and Carol Ritchie

Chris Shank and Anna Anderson

Sue and Kurt Watson

IBM Matching Grants Program

Becky and Todd Middleton

Stephen and Ann Starch

Trish Higgins

Donna Preston

Sonia Greteman and Chris Brunner

Marni Vliet Stone and David Stone

Dr. Christopher A. Moeller

Casey Voegeli

Mary Douglas Brown

Susan and Richard Skibba

Anita Jones

John and Cindy Carnahan

Ruthie and Jim Gillespie

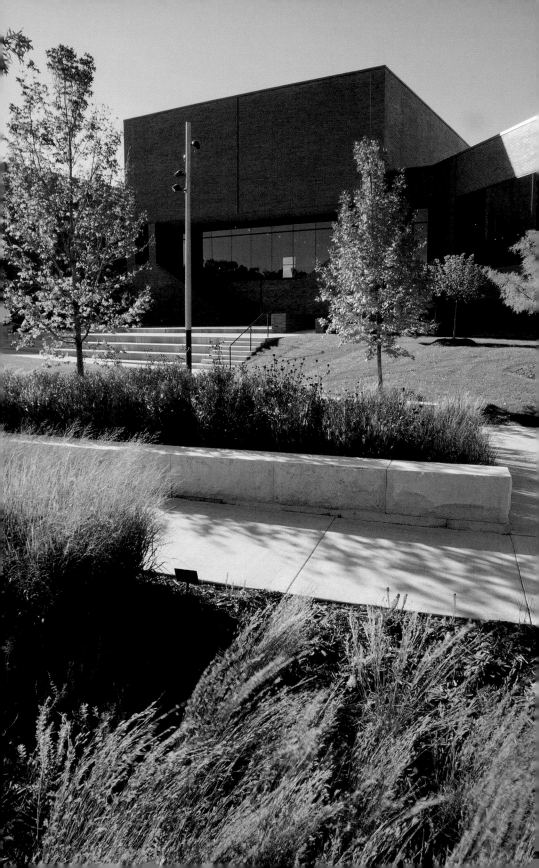

# Wichita Art Museum
# 2015 Board of Trustees

Text and photography © 2018
Wichita Art Museum

Book © 2018
Scala Arts Publishers, Inc.

Edited by Mariah Keller

Designed by Diane Gottardi

First published in 2018 by
Scala Arts Publishers, Inc.
c/o CohnReznick LLP
1301 Avenue of the Americas
10th floor
New York, NY 10019
www.scalapublishers.com
Scala – New York – London

Distributed outside the
Wichita Art Museum by
ACC Distribution
6 West 18th Street
4th floor
New York, NY 10011

ISBN: 978-1-78551-164-6

Library of Congress Cataloging-in-Publication Data
Names: Wichita Art Museum, author.
Title: The Art Garden : Wichita Art Museum.
Description: New York : Wichita Art Museum in association with
   Scala Publishers, 2018.
Identifiers: LCCN 2017046305 | ISBN 9781785511646 (pbk.)
Subjects: LCSH: Art Garden (Wichita, Kan.) | Outdoor sculpture–
   Kansas–Wichita. | Public sculpture–Kansas–Wichita.
Classification: LCC NB1278 .W53 2018 | DDC 730.9781/86–dc23
LC record available at https://lccn.loc.gov/2017046305

Author: Dr. Patricia McDonnell
Project Manager: Teresa Veazey
Editor: Dr. Emily Stamey
Photography: Larry Schwarm with additional
   photographic contributions from Kirk Eck and
   Method Productions
Landscape Consultant: Larry Hoetmer

Printed and bound in China
10 9 8 7 6 5 4 3 2 1

Page 10: © Douglas Abdell; Page 11: © Estate of Stanley
Boxer/Licensed by VAGA, New York, NY; Page 12. © Tony
Hochstetler; Page 13: © Steve Kestrel; Page 14: Reproduced
by permission of The Henry Moore Foundation; Page 15: ©
Tom Otterness/tomotterness.net; Pages 18–19: © Vicki Scuri,
Vicki Scuri SiteWorks with Alex Polzin; Page 20: © Ernest
Shaw; Page 39: Reproduced with permission of the Charles
E. Burchfield Foundation; Page 40. © 2017 Mark Tobey/
Seattle Art Museum, Artists Rights Society (ARS), New
York; Page 41: Courtesy The Demuth Museum, Lancaster,
PA; Page 42: © 2017 Andrew Wyeth/Artists Rights Society
(ARS), New York; Page 43: © Romare Bearden Foundation/
Licensed by VAGA, New York, NY; Page 44: © 2017 Estate
of Louise Nevelson/Artists Rights Society (ARS), New York;
Page 45: © Grace Hartigan Estate; Page 46: © Roger
Shimomura; Page 47: © David Salle/Licensed by VAGA,
New York, NY; Page 48: © Larry Schwarm; Page 49:
© Fred Wilson, Courtesy Pace Gallery

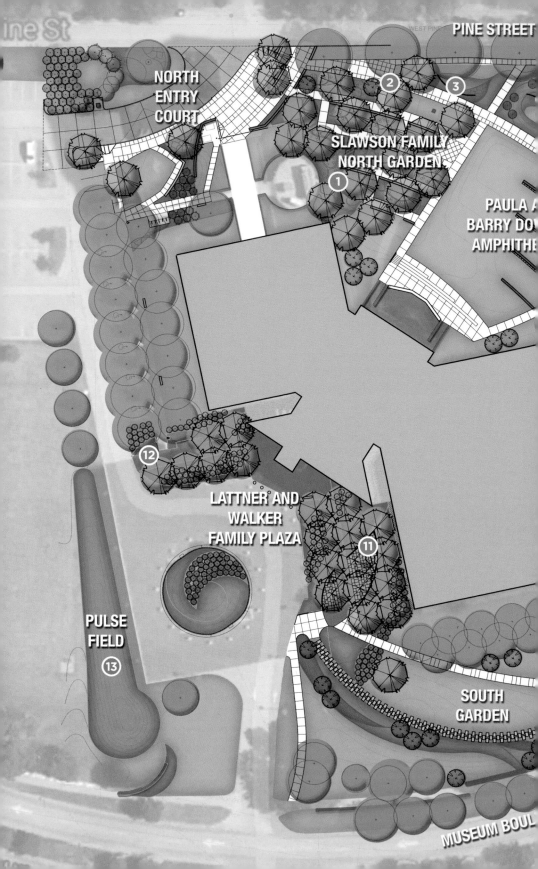